MEHNDI
BODY PAINTING

IMPORTANT NOTE

MEHNDI IS FOR EXTERNAL USE ONLY.

WARNING

Any contact with the eyes should be avoided. However, if you do get mehndi in the eye, wash your eyes immediately with cold water, or rinse with an eye bath. If symptoms persist then contact your doctor immediately.

For further information please read pages 9 to 12.

Published by Contemporary Books
A division of NTC/Contemporary Publishing Group, Inc.
4255 W. Touhy Avenue, Lincolnwood (Chicago), Illinois 60646-1975 U.S.A.

Text, book design, and illustrations copyright © Carlton Books Limited, 1998
Original mehndi designs copyright © Zaynab Mirza, 1998

International Standard Book Number 0-8092-2801-7

Library of Congress Cataloging-in-Publication data is available
from the Library of Congress.

PROJECT EDITOR: Julian Flanders
COPY EDITOR: Ali Glenny
DESIGNER: Mary Ryan
ILLUSTRATOR: Peter Cox
PRODUCTION: Garry Lewis

Printed and bound in Great Britain

MEHNDI
BODY PAINTING

Zaynab Mirza

CB
CONTEMPORARY BOOKS

ABOUT THE AUTHOR

Zaynab Mirza is a fully trained beauty therapist and make-up artist. With expertise in both eastern and western beauty techniques, she specialises in bridal matters, and is kept busy thoughout the year travelling all over the UK and Europe preparing brides for their big day. She runs her own beauty school in London where she offers courses in all aspects of both Asian and western beauty therapy, including a comprehensive course in mehndi for the beginner.

Zaynab appears regularly on television and radio as a beauty and fashion consultant, and has a regular column in several Asian magazines and newspapers.

Mehndi Body Painting is her first book.

CONTENTS

CHAPTER 1

AN INTRODUCTION TO MEHNDI

What is Mehndi?

Mehndi — *henna* in English — is best known in the West as a reddish-brown hair dye with conditioning properties that make it a popular ingredient in hair-care products. In the East, however, it has also traditionally been used as a skin colourant and is central to the long tradition of temporary tattooing which is the subject of this book.

Mehndi is the dried and powdered leaf of the dwarf shrub *Lawsonia inermis,* a member of the Loosestrife family, Lythraceae, which grows to a height of about 2½–3m. A distilled water preparation used for cosmetic purposes is made from its small, sweet-smelling, pink, white and yellow flowers. It grows in hot climates and is supplied mainly from Arabia, Iran, Ceylon, India, Egypt, Pakistan and Sudan, though it may also come from China, Indonesia or the West Indies.

The Beginnings of Mehndi

The history of mehndi goes back 5000 years. It is said to have been used in ancient Egypt to colour the nails and hair of mummies. In the 12th century, the Mughals introduced it into India, where it was most popular with the Rajputs of Mewar (also known as Udaipur) in Rajasthan, who mixed it with aromatic oils and applied it to the hands and feet to beautify them. From then on mehndi has been regarded as essential to auspicious occasions, particularly weddings.

It was only after reaching India that mehndi gained real cultural importance, its use by the rich and royal making it popular with the people. Servants who had learnt the art of mehndi by painting the hands and feet of princes and princesses (with fine gold or silver sticks) were much sought after in towns and villages for their skills. As the use of mehndi spread, recipes, application methods and designs grew in sophistication.

In Persian art — most notably in a famous series of miniatures dating from between the 13th and 15th centuries — women taking part in wedding processions and dancers are depicted with mehndi decoration on their hands. It has been suggested that in the scorching heat of Arabia, mehndi was often used on the skin for its coolant properties.

Hindu goddesses are often represented with mehndi tattoos on their hands and feet, and Muslims have used mehndi since the early days of Islam. It is said that the prophet Muhammed used it to colour his hair as well as, more tradi-

tionally, his beard. He also liked his wives to colour their nails with it. That Muhammed was and remains a model of perfection for Muslims has ensured the continuing popularity of mehndi as a decorative art within Islam.

Mehndi Across Cultures

With the passing of centuries, mehndi has gained in significance in cultures within the Middle East, Asia and north Africa. All of these communities use mehndi for the same purpose: to decorate and beautify; however, each one has its own unique designs, inspired by indigenous fabrics, the local architecture and natural environment, and individual cultural experiences.

In south India, a circular pattern is drawn and filled in in the centre of the palm. Then a cap is formed on the fingers, as if they had been dipped in mehndi. This design is used by most Asian elders, as in the early days before cones were available it was simple to apply. It is this design that is used by south Indian classical dancers.

In north Africa, very intricate designs are developed around peacock, butterfly and fish images, which are completed with finely detailed patterns. The effect is that of a lace glove, as great attention is given to filling in the gaps that surround the main motif. Religious symbols are incorporated, such as the *doli*, a form of hand-pulled carriage which was used to transport the bride from her home to her in-laws' house in the days before cars. The lotus is also popular.

Many people confuse Pakistani with north Indian designs, because both are intricately applied to give a lacy glove-like effect. In fact, however, Pakistani designs are a blend of the north Indian style and Arabic motifs – flowers, leaves and geometrical shapes. This choice of motif derives from religious teachings: Muslims may not pray with figurative representations on the body, and so do not employ designs depicting human faces, birds or animals.

Arabic patterns are well spaced on the hand, and traditionally completed by dyeing the nails with mehndi to give a deep stain.

Sudanese patterns are large bold and floral, with geometric angles and shapes, normally created with black Henna.

Mehndi in Wedding Customs

Mehndi has great significance in all Eastern wedding traditions, and no wedding is complete without the decoration of the bride's hands and feet – in many cultures on both the front and back of the hands right up to the elbow, and on the bottom half of the legs. The mehndi night is something like a hen night in the West, with all the bride's female friends and relatives getting together to celebrate. They spend the evening singing traditional mehndi songs, which tell of the good luck and blessings that the mehndi will bring, and of its significance with different in-laws.

"Phir neend kahan atee hai, jab lag jaatee hai, mehboob kee menendi haathon mein".
("Oh, how sleep is hard to come by, once her hands have been adorned with the mehndi of her beloved".)

"Mehndi sey likh doh re, haathon pe sakiyonh mereh savariya ka naam. Kitna suhaana sameh hai lagan ka".
("Oh, friends, come and decorate my hands with mehndi, write my beloved's name. Just see how auspicious this occasion is".)

"Sab kee takdeerenh, haath kee lakieeren in lakeeron pe banaye mehndi tasveeren".
("Everyone's fate is held within the lines on our palms, it is on these palms that mehndi paints such beautiful pictures".)

The mehndi night is common in the Gulf regions of Saudi, Bahrain, Kuwait and the UAE. Here, the celebration is generally held a few days prior to the wedding, and is strikingly similar to that of Indian culture. The bride has her hands and feet painted, and traditional songs are sung by the mothers and grandmothers, who tease her about her future. Mehndi also features in other Middle Eastern celebrations such as births and christenings.

In Gujerat, mehndi tattooing is part of the Adivasi women's wedding traditions. Leaves and flowers are used as templates around which complex designs are painted on the bride's face and arms.

The mehndi ceremony is considered so sacred in some religions that unless the mother-in-law has applied the first dot of mehndi to the bride's hand, the painting cannot go ahead. The mehndi dot is considered to be a symbolic blessing, bestowal of which permits the new daughter-in-law to beautify herself for the groom.

Many brides believe that the deeper the colour of the mehndi, the deeper the love they will receive from their in-laws, in particular the mother-in-law, whose blessing is particularly important to an Asian bride. Hence she does whatever she can to ensure that the mehndi stain is deep.

Traditionally, the groom's name is incorporated into the bride's mehndi tattoos, and it is his task to find it – which may take up to two hours. In some customs the bridegroom's hands are also decorated, and communities in Kashmir and Bangladesh have evolved particular men's designs. A current trend in the UK is for traditional patterns in the form of a ring or a bracelet.

FREQUENTLY ASKED QUESTIONS

THESE are the answers to the questions I am most frequently asked about mehndi. Read through them to gain a better understanding of the art.

Is mehndi the only other name for henna?

No, there are various other words for henna in different parts of the world. Mehndi, pronounced *Meh-hend-dee,* is the most common name. Others are *maruthani* (the Tamil or south Indian name), *saumer* (the Sudanese name for black henna) and *reseda*.

How long does it last?

Once stained, the design will last from a few days up to a few weeks, depending on its depth, the area of the body tattooed, and how much the area is exposed to soap, rubbing and – above all – water.

Are other colours available?

The only other colour available is *saumer,* black henna, mostly supplied from Sudan. *Saumer* is also becoming extremely fashionable and is very popular with men, because it gives similar tone to that of a permanent tattoo (but, like mehndi, is temporary). *Saumer* is most commonly used by both men and women on the soles of the feet.

Can mehndi be made darker?

As mehndi is an art form, there are many different variations in recipes, all of which affect the intensity of the final colour. (See Recipes for Preparing your own Mehndi, page 12.)

Is it safe?

Mehndi has been used safely for over 5000 years, and because it is a completely natural product (100% pure) allergic reactions are very rare. Nevertheless, as with any new product you try, do a patch test to rule out any possible allergy. Mehndi application is completely painless, and even children can be mehndi tattooed – providing they will sit still long enough!

Why the sudden interest in mehndi?

Of course, mehndi is not new in the East, where it is an ancient tradition. Interest in the West has been generated by the current vogue for body art. As a form of temporary tattoo, mehndi has gained new popularity as a fashionable means of decorating the body.

Temporary tattoos?

Various types of tattoo are very trendy at the moment. The popularity of mehndi tattooing is due to the fact that it is temporary. With fashion changing so rapidly, what is "in" today may not be the rage tomorrow, so why invest in a tattoo that you cannot change with your tastes?

Who is wearing mehndi tattoos?

Recently, various celebrities have been spotted wearing mehndi tattoos, including Demi Moore, Liv Tyler, Prince, Mira Sorvino, Naomi Campbell, Britain's No Doubt singer, Gwen Stefani and the artist formerly known as Prince.

Is mehndi tattooing a lengthy process?

The preparation and mixing take about half an hour, and once mixed the paste has to be left to mature in a cool dry place. Once the designs are complete, the mehndi must stay on the skin for a minimum of two hours, and up to eight hours to develop into a good stain. It takes about 48 hours for the mehndi to reach its deepest colour.

Does the mehndi start to crumble?

As soon as the mehndi begins to dry you need to apply a solution made of sugar and lemon to prevent it from flaking. The longer the mehndi stays moist, the better the colour will be.

How do I make the stain darker?

If you are happy with the colour – an orange-red – then rub your hands with some mustard oil once you have removed the dried paste. This helps to penetrate the skin deeper and bring out the colour.

Can I do mehndi by myself?

Applying your own mehndi tattoo is easy, unless you're planning on doing both your hands, in which case you might need someone else to help you.

Do I have to be artistic?

You do not necessarily have to be artistic, but a sense of creativity does help. Don't worry if you think you are not a creative person; as with any project you undertake, practice makes perfect. If you start at the beginning of the book and slowly work through it, you will find that you become proficient at using mehndi.

Can I buy ready-mixed mehndi?

Yes, mehndi can be bought pre-mixed, so if initially you are hesitant to mix

MAKING A PLASTIC CONE

ONCE YOU have made full use of the cone that is provided with the kit, you can try making your own plastic mehndi cone. This is easy to do and will only take a few minutes.

You will need:

Durable plastic (such as food bags or clear carrier-bags) • *Scissors* • *Strong adhesive tape*

STEP ONE
Cut a rectangle approx imately 16 cm x 12 cm into your plastic. Start to roll the plastic inwards from the left, shaping it into a cone. Ensure that you do not leave any gaps at the bottom.

STEP TWO
Once you have formed the cone, make sure you have secured it at the top and bottom and sealed the edges.

STEP THREE
Fill your cone about ¾ full of mehndi using a small spoon.

STEP FOUR
Fold both sides inwards then downwards about three times, and secure with tape.

STEP FIVE
Use a pin to make a tiny hole at the bottom of the cone. Your mehndi cone is now ready to use.

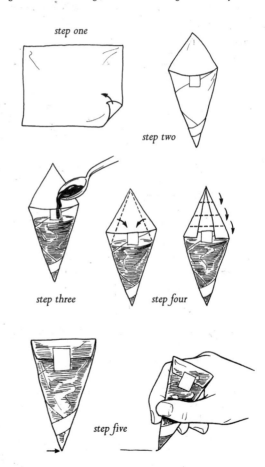

step one

step two

step three

step four

step five

CHAPTER 2 ▰▰▰▰▰▰▰▰▰▰▰

BASIC DESIGNS

T HIS SECTION has been designed for you to learn and gain confidence in the magical art of mehndi. It starts off with simple lines and progresses onto more intricate patterns. The designs that you will find on the next few pages are basic fillers. They can be used on various parts of the body, and are intended for filling in larger motifs or any gaps around your main design.

―――――――――――――― Exercise 1 ――――――――――――――

Complete the designs using a fine pencil point. This will get you familiar with drawing them with your cone later on.

———————————————— Exercise 2 ————————————————

On this page you will find simple shapes to practise with. These designs are
traditional, but there is no need to limit them to the hand; why not try drawing
them around the navel or shoulder blade, perhaps within a heart design?

Exercise 3

Here are some more simple designs for you to practise with. You can use your imagination in deciding where to place them.

---------------------- Exercise 4 ----------------------

These are traditional fillers, usually used to complete larger shapes.

––––––––––––––––––––––––––– Exercise 5 –––––––––––––––––––––––––––

Complete these filler designs using a fine-point pencil.

Exercise 6

These designs can be used to complete patterns on any part of the body.

———————— Exercise 7 ————————

Complete these filler designs using a fine-point pencil.

Exercise 8

Complete these filler designs using a fine-point pencil.

CHAPTER 3

TRADITIONAL PATTERNS AND MOTIFS

Y OU HAVE NOW completed the learning section of the book, and are ready to start making up your own designs from scratch. To get you started, I have included some central motifs. These are made up of fillers you have already come across.

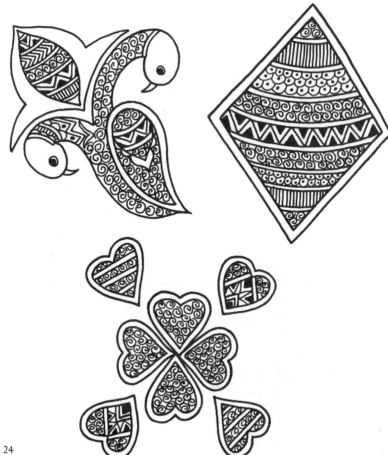

First of all, draw the outlines, then start filling in from the top, working downwards. NOTE: Outer lines should always be made slightly wider and thicker so that they are prominent.

These designs are not only excellent for making up your main hand pattern, but are also wonderful to draw on other parts of the body. The floral heart motif opposite is ideal to use on the shoulder blade, as is the diamond.

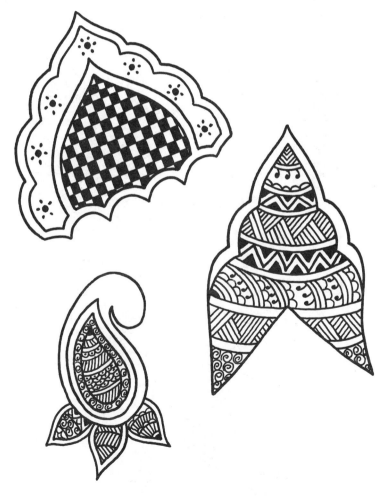

Here again you will find traditional motifs. These can be used as a base for building up patterns, and can be developed according to your own imagination. The more circular designs look excellent around the navel, where even the most traditional design has a modern feel.

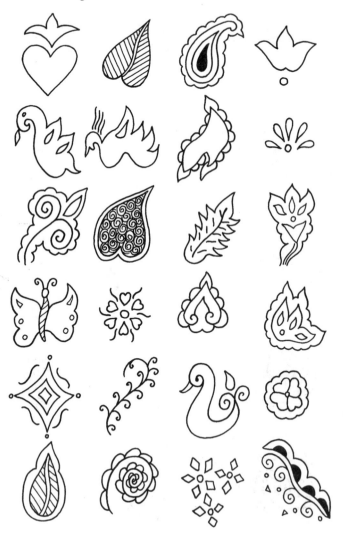

These flowers are fine if you just want one simple motif. They can be used wherever you like.

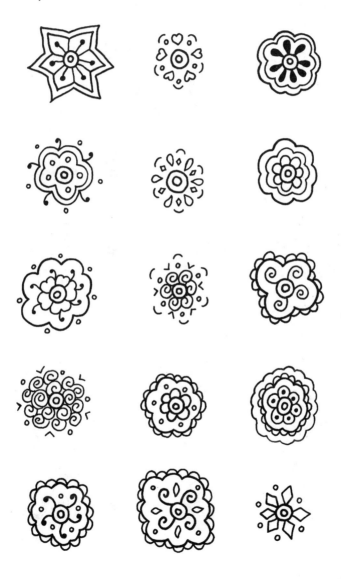

The designs you will find on this page are for the fingers or wrists but can also be used on other parts of the body. Why not try drawing them on the arms?

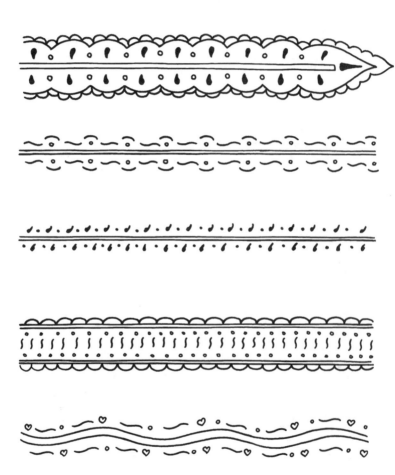

These simple motifs need not only be used on the hands. Try using them on the back or legs.

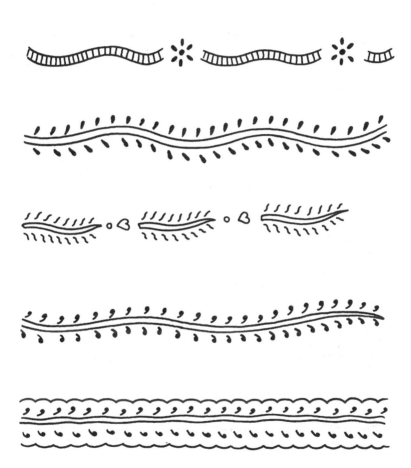

FINGER DESIGNS

Y OU WILL find various designs for the fingers on this page. These are very intricate, and look good combined either with less complex patterns or with modern shapes. All of these designs can be used on either side of the hand.

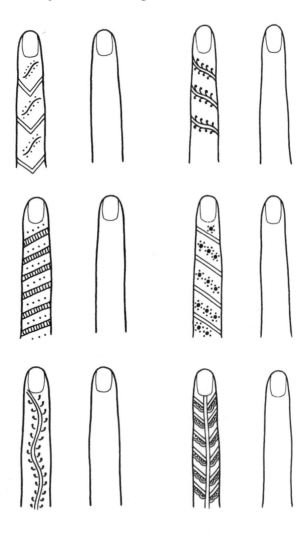

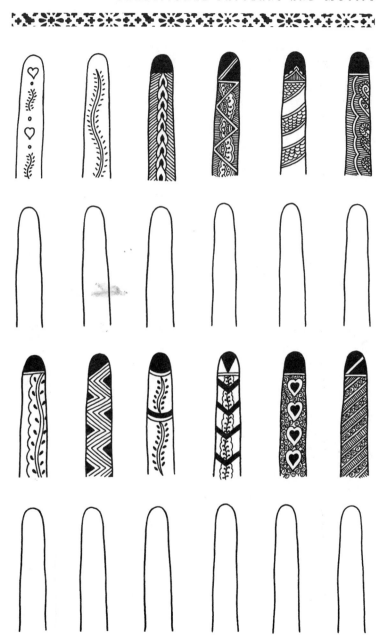

MODERN PATTERNS AND MOTIFS

THE DESIGNS you see here are modern motifs which can be drawn on any part of the body. They look especially good on the back of the hand, on the upper arm or above the ankle.

NOTE: Always start with the central design first, and draw outwards. This ensures that the design is well spaced and not squashed. Always leave a gap of about 4 mm so that if the mehndi runs, your design will not be spoilt.

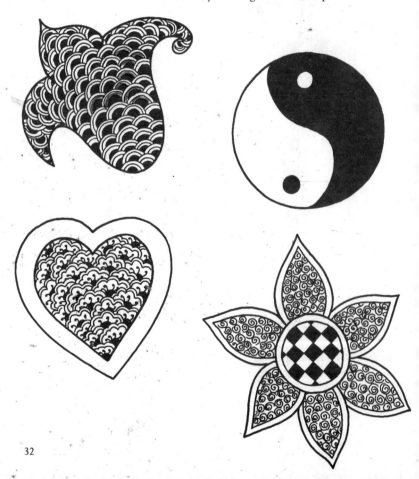

Where fillers are included, start in the centre and draw outwards; otherwise draw the outlines first, and then fill in the pattern where required.

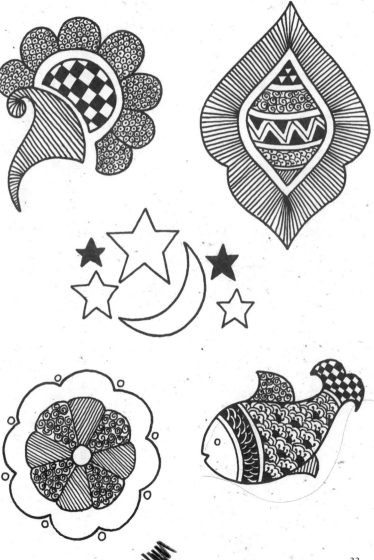

The sun design is excellent for drawing around the navel, or maybe — if you're daring enough — around the nipple area, as sported by fashion models on catwalks around the world.

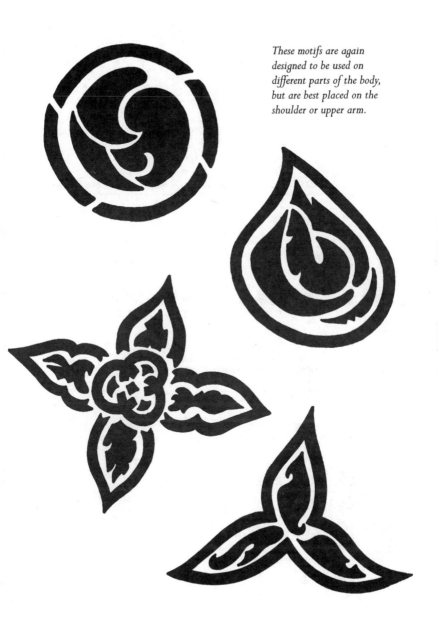

These motifs are again designed to be used on different parts of the body, but are best placed on the shoulder or upper arm.

The designs you will find on the next two pages are for the upper arms or the ankles. Start by drawing the outlines first. The bolder designs need a slightly thicker outline, with a second thinner line around it. Then continue to draw the central filler design.

PUTTING IT TOGETHER

O NCE YOU have built up confidence in creating the basic shapes and patterns and filling in the detail, it is time to put your preparation into your first complete design. Use the patterns around the hand drawing to fill in the design. Feel free to change or improvise on any design.

Start by filling in the central heart outlines, working downwards towards the wrist. Then work upwards to complete the fingers.

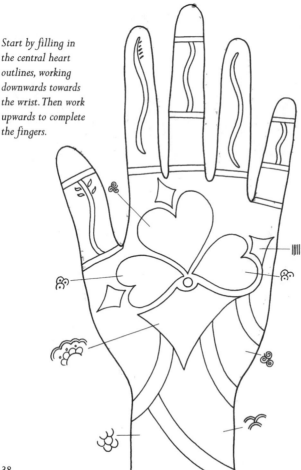

Start by filling in the main motif in the palm. Once the palm is finished, proceed to the fingers and fill in using the patters indicated.

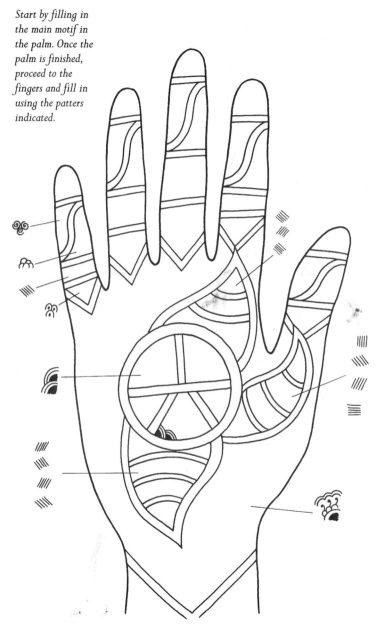

This design is made up of an outline to be filled in around the hand with the patterns indicated. Make sure that the designs are kept within the outlines. Once the design is complete, you will have traditional intricate patterns separated by a bold outline.

For this traditional pattern, start on the fingers, and then work downwards, filling in the central motif. Finish on the wrist.

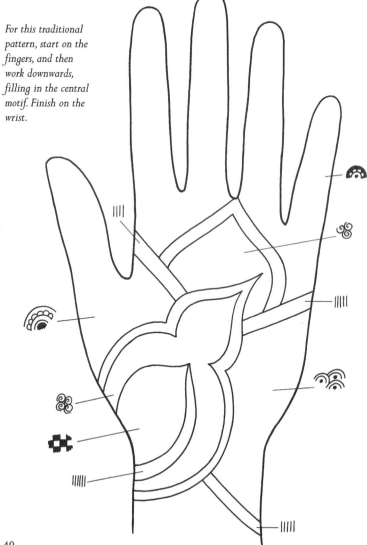

Start by filling in
the diamond in
with your choice of
pattern. Then do the
two arcs on either
side. Proceed to the
fingers, and finish
by doing the wrist.

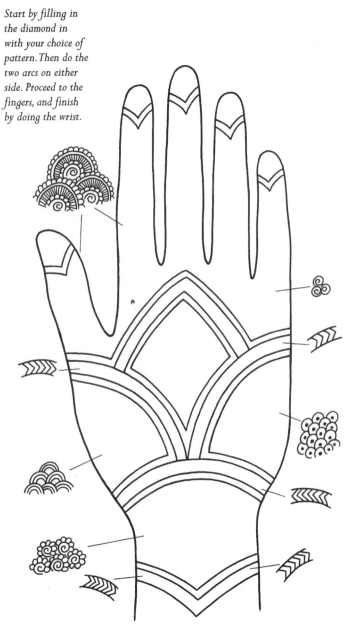

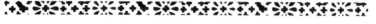

The design on these two pages is complex, but if you study it carefully you will see that it is made up of simple patterns that you have come across earlier in the book. Begin by filling in the middle outlines, working from the central heart outwards. Then start on the fingers, working from the left out towards the right and finishing on the thumb. Continue the design down towards the left, so that when you finish you are back on the left-hand side of the right hand.

CHAPTER 6

DESIGNS FOR YOU TO COPY

Now that you have seen and drawn the motifs, fillers and arm, ankle and finger designs, you can proceed to the full hand and foot designs. From this page onwards you will find complete designs. Some of these are traditional Pakistani, Indian and other Asian patterns, some are Arabic-inspired and others are modern.

This particular design is an Arabic inspiration. Arabic designs are made up mainly of flowers and geometrical shapes spread out along the hand.

To copy this design, start by drawing the central rectangular grid, followed by the bottom left pattern for the thumb. Then proceed onto the left-hand side above the grid, and finally onto the fingers.

It will take about 30 minutes per hand to complete this design.

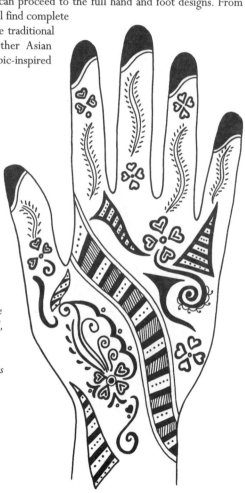

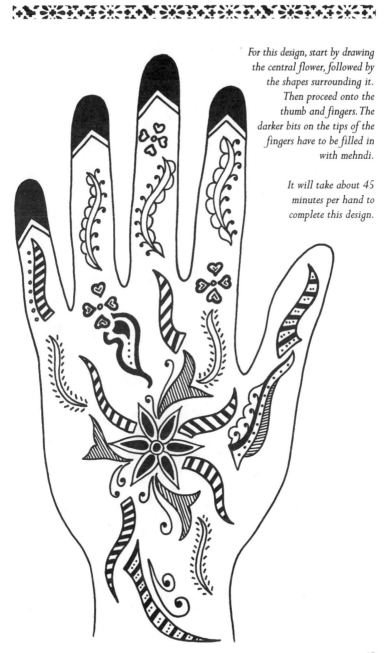

For this design, start by drawing the central flower, followed by the shapes surrounding it. Then proceed onto the thumb and fingers. The darker bits on the tips of the fingers have to be filled in with mehndi.

It will take about 45 minutes per hand to complete this design.

This design is a continuation of those on the previous pages. This time it is for the top of the hand. Start on the finger, then proceed down onto the hand. The bolder shapes need to be filled in using your cone.

It will take about 20 minutes per hand to complete this design.

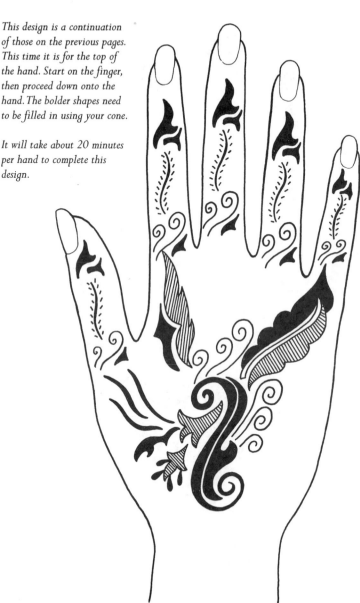

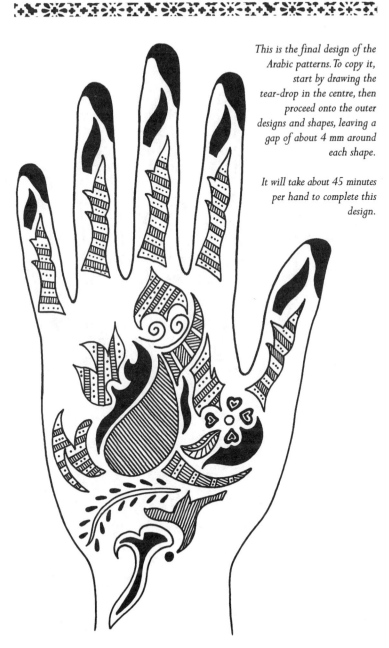

This is the final design of the
Arabic patterns. To copy it,
start by drawing the
tear-drop in the centre, then
proceed onto the outer
designs and shapes, leaving a
gap of about 4 mm around
each shape.

It will take about 45 minutes
per hand to complete this
design.

For this design, start by drawing
the outlines. Draw the bottom
arch first, then the surrounding
arches. Next, start to fill in the
design from the palm of the
hand upwards, completing the
fingers one by one. Finally
complete the wrist and
palm downwards.

It will take
about one hour
per hand to
complete this
design.

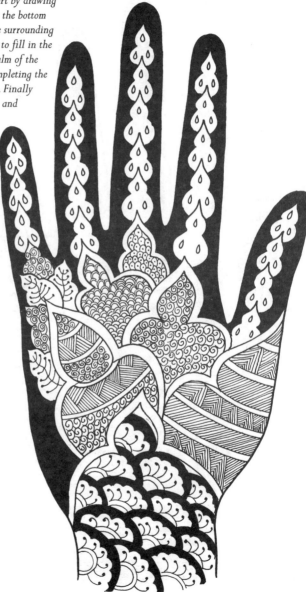

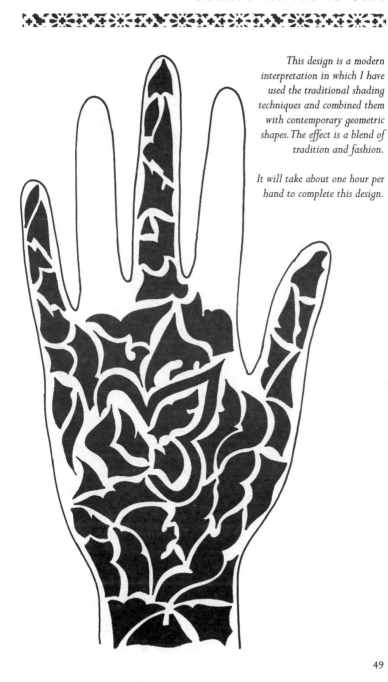

This design is a modern interpretation in which I have used the traditional shading techniques and combined them with contemporary geometric shapes. The effect is a blend of tradition and fashion.

It will take about one hour per hand to complete this design.

This design uses hearts as the central motif, filled in with fillers that you have come across earlier in the book. To copy this design, first draw the division in the hand half-way across. Draw the leaves and the outer curves, and then proceed onto the small heart, followed by the outer hearts, building the designs up towards the fingers. Finish off back down towards the wrist.

It will take about one hour per hand to complete this design.

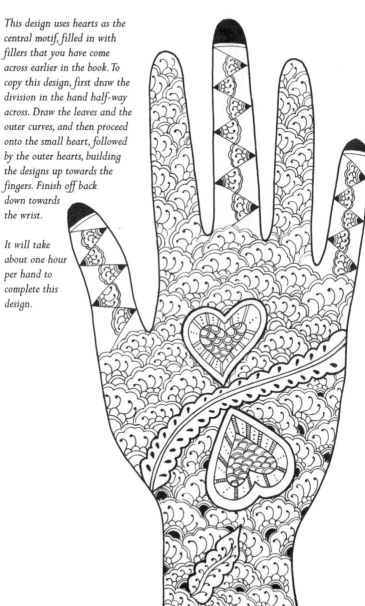

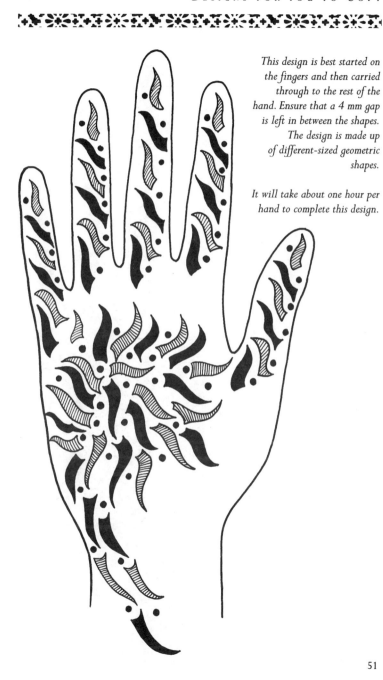

This design is best started on the fingers and then carried through to the rest of the hand. Ensure that a 4 mm gap is left in between the shapes. The design is made up of different-sized geometric shapes.

It will take about one hour per hand to complete this design.

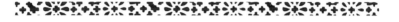

Start this design by drawing the central leaf outlines. Keeping a gap of about 3 mm between the lines, draw all the outlines, then begin to fill them in. Start with the fingers, working away from the thumb. This ensures that you do not smudge the design you have already created.

It will take about 1 hour and 15 minutes per hand to complete this design.

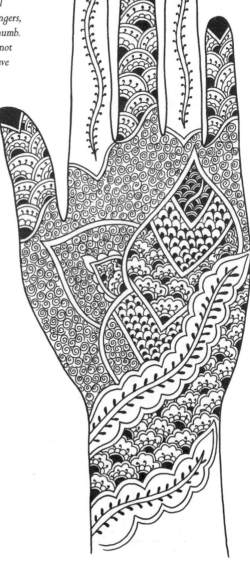

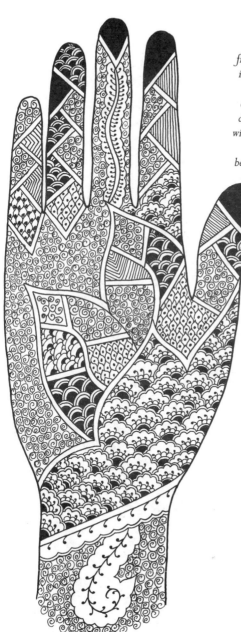

This design is made up of central curves and outlines filled in with finer and more intricate patterns which you have already come across earlier in the book. Start by drawing the outer lines. This will give you a good complete stencil to work with. Then begin to fill in the designs as shown. It is always better to work upwards from the palm onto the fingers.

It will take about 1 hour and 30 minutes per hand to complete this design.

53

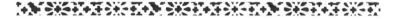

The central motif in this design is a butterfly combined with a peacock. To make this design, start by drawing the butterfly and peacock, then proceed outwards, drawing the outlines. Next, draw the lines on either side of and below the central motif. Then move onto the fingers, drawing the fillers as they appear, and working downwards to fill in all the large areas.

It will take about one hour and 30 minutes per hand to complete to complete this design.

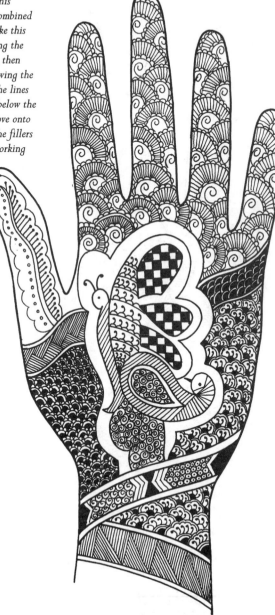

This design is for the front of the hand, and is complementary to the peacock design featured. To copy it, start by drawing the peacock, then draw the outer lines, and finally the finger designs. Once the outlines have been drawn, you can go back and fill in the patterns.

It will take about 35 minutes per hand to complete this design.

This design is for the front of
the hand. Start by drawing the
outlines of the central shape,
then proceed onto the fingers.
Once all the outlines have
been drawn, fill in the designs
with the finer patterns shown.

It will take about 35 minutes
per hand to complete this
design.

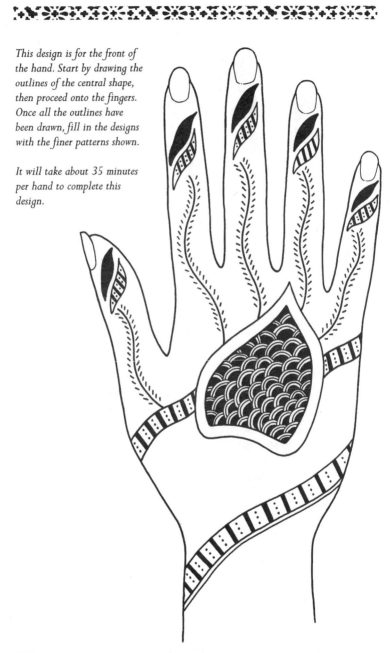

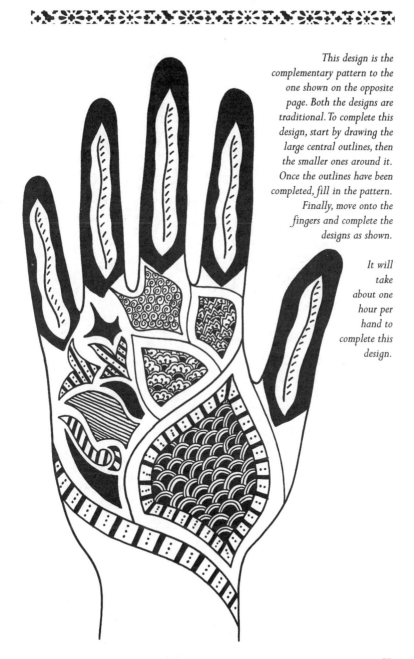

This design is the complementary pattern to the one shown on the opposite page. Both the designs are traditional. To complete this design, start by drawing the large central outlines, then the smaller ones around it. Once the outlines have been completed, fill in the pattern. Finally, move onto the fingers and complete the designs as shown.

It will take about one hour per hand to complete this design.

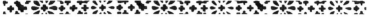

To copy this pattern, start by
drawing the rectangular lines
across the hands, so that you
have your division point. Then
draw the arch outline above,
followed by the heart. Once
your outline is complete, start
filling in the pattern from the
arch, moving onto the heart,
then the rectangular grid. Work
upwards, filling in the hand
with the designs as shown.
Complete the
fingers and
move down,
working
below the
grid. Finish the
design just
below the wrist.

It will take about
1 hour and 30
minutes per hand to
complete this
design.

This is a traditional Indian design using the peacock motif. Draw the central motif first. The outer line should be about 5 mm away from the motif. Once all your outlines are complete, proceed to fill in the motif, then fill in around it, following the pattern. Once the palm is complete, start the pattern on the fingers, beginning with the little finger and working towards the thumb.

It will take about one hour and 30 minutes per hand to complete this design.

This design is for the front of the hand. Although the filler patterns are traditional, the band across the hand is a modern interpretation. This design is better when started on the fingers, so that you can work downwards, protecting your design from the smudging which can occur when working the other way.

It will take about 30 minutes per hand to complete this design.

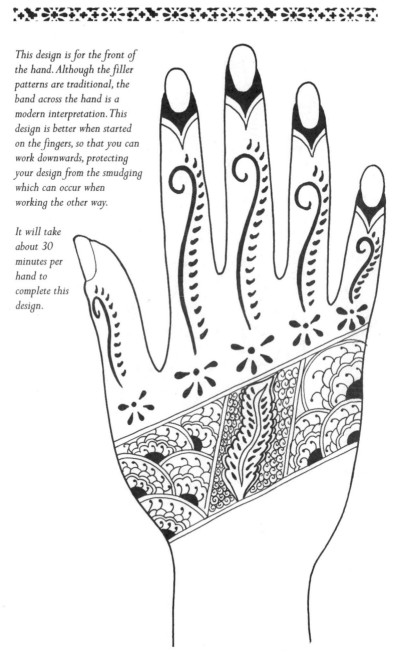

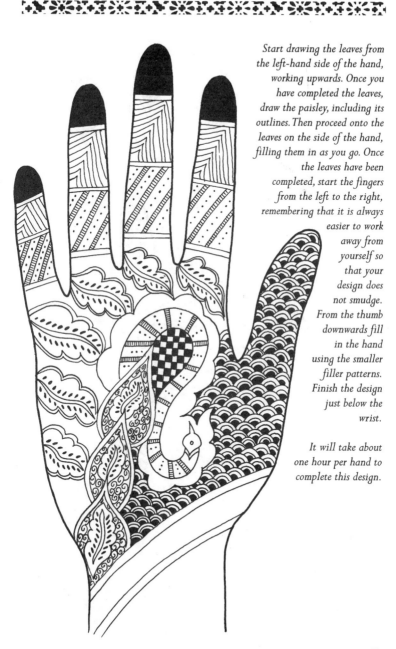

Start drawing the leaves from the left-hand side of the hand, working upwards. Once you have completed the leaves, draw the paisley, including its outlines. Then proceed onto the leaves on the side of the hand, filling them in as you go. Once the leaves have been completed, start the fingers from the left to the right, remembering that it is always easier to work away from yourself so that your design does not smudge. From the thumb downwards fill in the hand using the smaller filler patterns. Finish the design just below the wrist.

It will take about one hour per hand to complete this design.

Mehndi on the feet is fast becoming as trendy as mehndi on the hands. Originally it was associated with brides and weddings, and was used as a coolant for the soles of the feet in hot climates. Patterns can be as simple or as complex as you want. This design is of a traditional nature – something this intricate would normally be sported by brides.

To make this design, start by drawing the V-shaped grid. Then draw the semi-circle above it, filling in each pattern as shown. Continue to draw the leaves and the rest of the design up to the ankle. Once that is complete, proceed to draw the leaves below the V-shaped grid, working downwards and finishing on the toes.

It will take about 45 minutes per foot to complete this design.

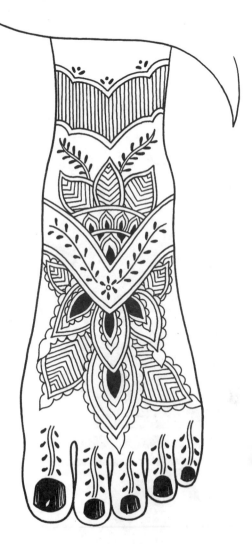

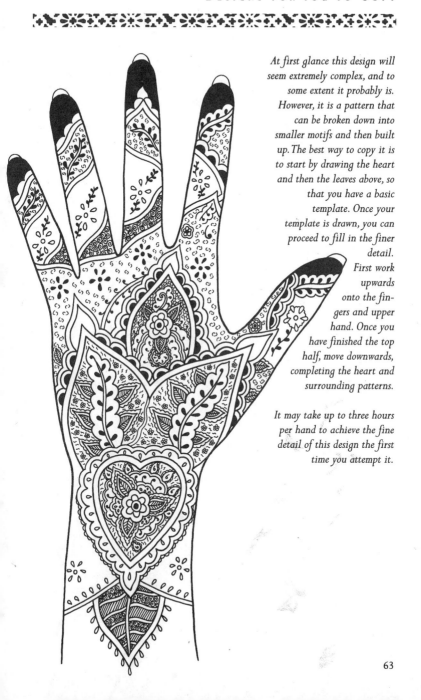

At first glance this design will seem extremely complex, and to some extent it probably is. However, it is a pattern that can be broken down into smaller motifs and then built up. The best way to copy it is to start by drawing the heart and then the leaves above, so that you have a basic template. Once your template is drawn, you can proceed to fill in the finer detail. First work upwards onto the fingers and upper hand. Once you have finished the top half, move downwards, completing the heart and surrounding patterns.

It may take up to three hours per hand to achieve the fine detail of this design the first time you attempt it.

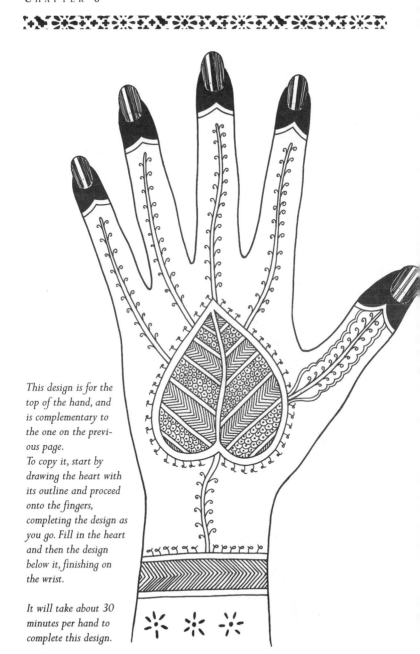

This design is for the top of the hand, and is complementary to the one on the previous page.
To copy it, start by drawing the heart with its outline and proceed onto the fingers, completing the design as you go. Fill in the heart and then the design below it, finishing on the wrist.

It will take about 30 minutes per hand to complete this design.

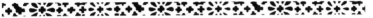

This foot design goes with those for the hand on the previous pages. To copy it, draw the heart and fill in the pattern. Complete it by working upwards towards the ankle, then downwards towards the toes.

It will take about 30 minutes per foot to complete this design.

65

This is a traditional pattern with a modern touch, created by the use of lines, which give the overall design its geometric look. To make this design, start by drawing the heart and the arch above it, including the outlines, then complete the heart with the fillers, working upwards towards the fingers. Once these have been completed, continue onto the design below the heart, finishing beneath the wrist.

It will take about 1 hour and 30 minutes per hand to complete this design.

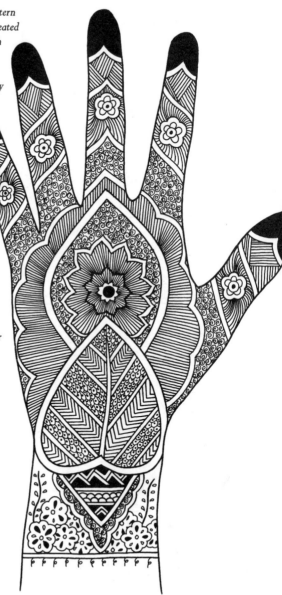

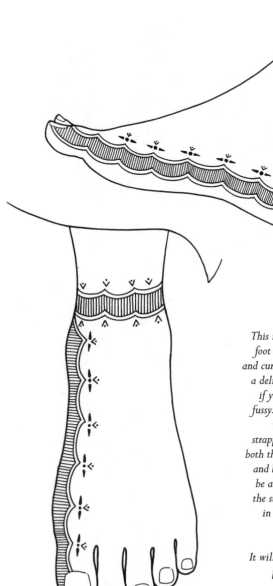

This is a very simple, modern foot design made up of lines and curves. It uses mehndi with a delicate touch, and is great if you don't want anything fussy. It looks especially good when you are wearing a strappy shoe. To copy it, draw both the outer lines on the top and bottom. The strip should be about 1.5 cm wide. Once the strip has been drawn, fill in using straight fine lines about 3 mm apart.

It will take about 20 minutes per foot to complete this design.

Again, this design appears fairly complex, but if you look closely you will see that it can be broken down quite easily. Start by drawing the heart as your central motif, and then draw the paisley, followed by the lines that separate the two motifs. The fingers should be drawn in when the top half of the palm is completed. Once the fingers are finished, proceed downwards below the paisley, filling in the outlines as you go along. This design will finish half-way between the elbow and wrist.

It will take up to two hours to complete this design.

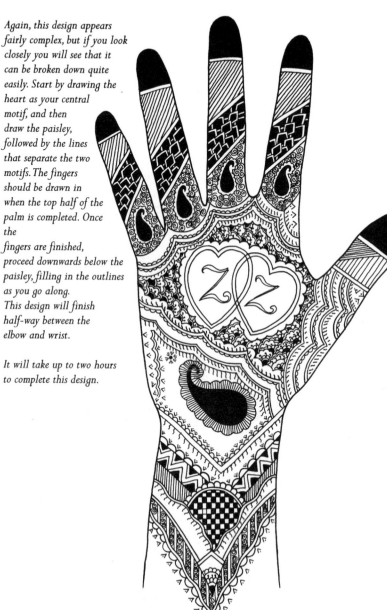

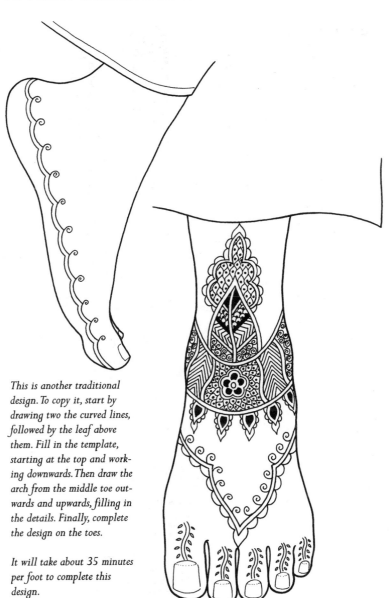

This is another traditional design. To copy it, start by drawing two the curved lines, followed by the leaf above them. Fill in the template, starting at the top and working downwards. Then draw the arch from the middle toe outwards and upwards, filling in the details. Finally, complete the design on the toes.

It will take about 35 minutes per foot to complete this design.

This is a very traditional and intricate pattern, and is designed to be drawn as a mirror image on both hands. It is very popular with my brides, especially when they are looking for a symmetrical design. To start this pattern, draw the paisley, followed by its outlines. Then proceed onto the fingers, filling in each one as detailed. Once the fingers have been completed, fill in the fine detail around the paisley. Start to make tiny squiggles along the hand. Once completed, work downwards, drawing outlines and filling in each one as you go along. Proceed down from the wrist onto the forearm. This design will end half-way between the wrist and elbow.

It will take up to five hours to complete this design, as there is a lot of detail involved in both hands.

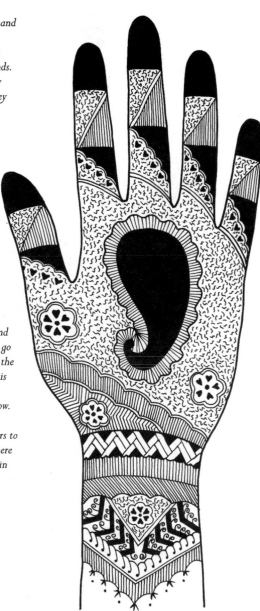

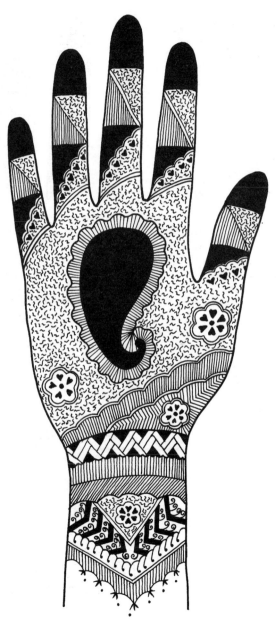

USEFUL INFORMATION

B ELOW YOU will find names and addresses which you may find useful, along with mail order details and information on ordering mehndi packs.

If you would like more information about things featured in this book, mehndi artists in your area, professional mehndi courses, or you have other general enquiries, contact:

Zaynab Mirza,
The Institute of Beauty Culture,
1st Floor,
118 Churchfield Road,
London W3 6BY
England
Tel: (44) 0181 993 9526
Fax: (44) 0181 993 9773
Email: bbzaynab@aol.com

There is also a wide range of mehndi products available by mail order. Should you wish to purchase any accessories for use at home or at mehndi parties, write for details and a price list to:

The Art of Mehndi,
PO Box 16796,
London W3 6ZN
England

Instructions for mehndi application

*(Before you start, we recommend that you read the full
instructions on pages 9 to 14 of the book included in this kit).*

1. Remove the adhesive tape from the top and bottom of the plastic cone.

2. In a cup or glass, dilute the mixing crystals with ¼ cup of warm water. To this add ½ of the mehndi oil (to open the oil sachet, just make a tiny snip at the top with a pair of scissors), mix thoroughly and leave to stand for a couple of minutes. (Keep the remainder of the mehndi oil upright in a cup or glass – making sure not to spill any).

3. Using either a spoon or a funnel, slowly pour the mixture into the cone, ensuring that you manipulate it with your fingers as you pour. When you have added about ¾ of the liquid, reseal the top of the cone with the adhesive tape, and continue to manipulate it until the powder and the liquid are completely mixed. The mixture should be about the same consistency as icing sugar. If some of the powder is still dry than add a little more liquid until you achieve the desired consistency. Put the mixture aside in a cool place for about 2 hours.

4. Using a fine pin, poke a hole right at the bottom of the cone. Remember, the smaller the hole the better for detailed design.

5. Your cone is now ready to use.

6. Before applying the mehndi, soak a cotton wool pad in the remaining mehndi oil, and use this to dampen the skin area where you intend to apply your pattern. This makes the skin more receptive to the mehndi and enriches the colour of the final image.

If using the transfer template, select your required design, cut roughly around the edge, and place it in position on an area of skin dampened with water. Press down on the transfer for several seconds with some damp cotton wool until the image is flat. Lift off and you will be left with an impression of the design on your skin. If necessary, smooth over with the cotton wool to ensure adhesion. Draw over this using the mixed mehndi in the cone.

(Batch 1)

MEHNDI
BODY PAINTING

Important Note
Mehndi is for external use only.

WARNING

Avoid any contact with the eyes. However, if you do get
any of the substances contained in this pack in the eyes,
do not rub them, wash immediately with cold water,
or rinse with an eye bath. If symptoms persist then
consult your doctor immediately.

The mehndi oil included here is terpineol. In tests, some
allergenic properties have been reported from its usage.
If you think you might be allergic to it, place a drop of
the oil on the back of your hand, and wait a few minutes.
Wipe off the oil. If a red spot remains then do not
proceed with the application.

Mehndi does leave stains, so protect your work area with
sheets or newspaper, cover your clothes and keep away
from upholstery.